Tattoos in Modern Society

Janey Levy

Published in 2009 by The Rosen Publishing Group, Inc.
29 East 21st Street, New York, NY 10010

First Edition

Library of Congress Cataloging-in-Publication Data

Levy, Janey.
Tattooing : tattoos in modern society / Janey Levy.—1st ed.
 p. cm.-(Tattooing)
Includes bibliographical references and index.
ISBN-13: 978-1-4042-1829-1 (lib. bdg.)
1. Tattooing. I. Title.
GN419.3.L49 2008
391.6'5—dc22

 2007053006

Manufactured in Malaysia

On the cover: Top: Famed tattooist Don Ed Hardy doesn't limit his artistic expression to tattooing. These shoes provide just a couple of examples of the many Hardy tattoo designs that decorate lines of shoes and clothing. Bottom: Center Al Johnson of the Arizona Cardinals walks onto the field during a game. Tattoos on his upper arms are visible even with his uniform on.

Contents

INTRODUCTION

Tattooing is a permanent form of body art made by using inked needles to create a design in the skin. Some designs involve only black ink. Others use many colors. What makes the tattoo permanent is that the needles penetrate below the skin's surface. The needles puncture the outer layer of skin, called the epidermis, and reach to the layer of skin below, called the dermis. Getting a tattoo usually involves pain and some bleeding.

How long does getting a tattoo take? It can take anywhere from thirty minutes for a small, simple tattoo to many hours spread over several visits for a large, complex tattoo. Most people who get tattoos feel that the finished skin art is worth whatever pain they experience. In fact, for many people, the painful and time-consuming process is as important as the final product.

Tattoos are everywhere today. You may associate them with celebrities such as actors, singers, and athletes. Some celebrities have many tattoos, and they're often in highly visible places on the wearers' bodies. Celebrities have inspired many people to get tattoos, and you may have friends or family members who have been tattooed. However, you might be surprised to learn that professional people such as your family doctor or the lawyer who lives down the street also have

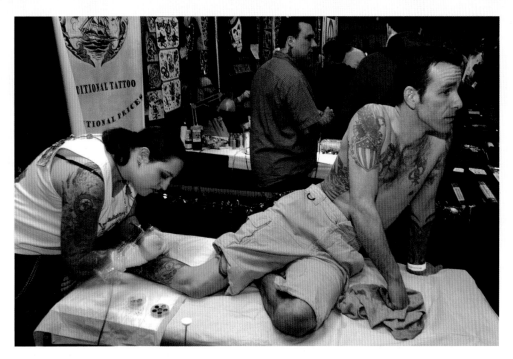

Numerous cities across the United States host tattoo conventions every year. Tattoo artists from around the country gather to display their work and learn about new tools and techniques. Tattoo enthusiasts like the man shown here often take advantage of the opportunity to get new tattoos.

tattoos. You simply may not see theirs because they're likely to be hidden by clothing. There are even grandmothers and great-grandmothers who have gotten tattooed. According to Leanne K. Currie-McGhee in *Tattoos* and *Body Piercing* and Ina Saltz in *Body Type*, a recent poll indicated that 16 percent of people in the United States had at least one tattoo. The percentage of tattooed people varied by age group. Among people between the ages of eighteen and twenty-nine, 49 percent had tattoos. Among those over sixty-five, 7 percent had one or more tattoos.

Tattooing may seem like a very modern, hip, and cutting-edge phenomenon, but it has been practiced for tens of thousands of years. It has been performed in cultures all around the world, from northern Europe to the South Pacific. Traditional reasons for tattooing covered a wide range. A tattoo could be a form of defense or magic, an expression of spiritual devotion, proof of bravery, an indication of social status, an emblem of a rite of passage, or simply adornment.

Today, people get tattoos for many of the same reasons. Modern tattoos come in many styles, including tribal, traditional, Celtic, Oriental (or Japanese), and fantasy. Anchors, angels, butterflies, dragons, flowers, and hearts are common symbols. Tattoos can also be custom designed and highly personalized.

Western society's attitude toward tattoos has shifted back and forth over the last few centuries, alternately valuing tattoos or viewing them as socially unacceptable. Today, many people consider tattoos an art form. Numerous contemporary tattooists—or "ink slingers"—attended art school, and the artistic qualities of tattoos are widely recognized. Tattooing has moved from the shadowy margins of society and reemerged in the bright light of the mainstream.

Tattooing's History and Traditions

Tattooing has been practiced since before recorded history. In fact, it may have been one of the earliest art forms. No one knows for sure how or when tattooing was invented. Victoria Lautman suggests in *The New Tattoo* that it may have been discovered by accident, as often happened in human history. Perhaps some prehistoric person got ashes pressed into his or her skin when falling near a fire, liked the way it looked, and tried to reproduce it. Regardless of how humans discovered tattooing, we know they did discover it, perhaps in different ways and at different times in different places. Evidence tells us tattooing had a long history in Europe, Japan, Egypt, Polynesia, Russia, Greece, Rome, and the Americas. The oldest evidence for tattooing comes from prehistoric Europe.

Tattooing in Prehistoric and Ancient Europe

Archaeologists digging at sites across Europe have discovered small sculptures with marks

that resemble tattoos. They've also found 40,000-year-old implements that may have been tattooing tools. The instruments include bone needles, hollow bone tubes with traces of powdered pigment, disks of clay and reddish earth pigment, and bowls with traces of color. If the implements were indeed for tattooing, this means tattooing is as old as the earliest cave paintings, perhaps older.

Many possible reasons for prehistoric tattooing have been suggested. The tattoos may have been a form of defense, meant to frighten attackers. They may have been magic talismans believed to have the power to heal or protect the wearer. The tattoos may have been an expression of religious devotion. They may have been proof of bravery, since the crude tools would have made prehistoric tattooing extremely painful. They may also have been adornment, a way to beautify the wearer's body.

Tattooing continued to be important in cultures across Europe until the fourth century CE. Greek writers of the fifth century BCE recorded that neighboring civilizations used tattoos to indicate wealth, status, or noble birth. Ancient Greeks themselves used tattoos as a mark of ownership on slaves and to punish criminals. Ancient Romans learned about tattooing from the Greeks and, like them, used it to mark slaves. They also tattooed soldiers so they could identify any who deserted, or ran away.

Roman records of the third and fourth centuries CE tell about the Picts of ancient Britain. The name "Picts" means "painted people" and derives from the fact that they tattooed

The Iceman

In 1991, hikers found a mummified body projecting from a glacier in the Alps. Nicknamed "the Iceman," the 5,300-year-old mummy bore more than fifty tattoos, mostly groups of lines. They were on his lower back, his lower leg, the outside of his left ankle, and behind his knee. Several possible reasons for the tattoos have been suggested, including adornment, indication of status, and a token of magical power or protection. However, one scientist noted that many of the tattoos were placed at traditional acupuncture points—places where fine needles are inserted into the skin to relieve pain and treat certain diseases by stimulating nerve impulses. Based on this theory, many people think the Iceman's tattoos were meant as a form of healing.

or painted their bodies to frighten enemies. Another group of people in ancient Britain also tattooed themselves to terrify enemies. Their name—the Britons—comes from a word that means "painted in various colors."

Tattooing in Ancient Egypt

Before the discovery of the 5,300-year-old Iceman in the Alps, the oldest known tattoos were on 4,000-year-old mummies from ancient Egypt. Evidence suggests Egyptian tattooing

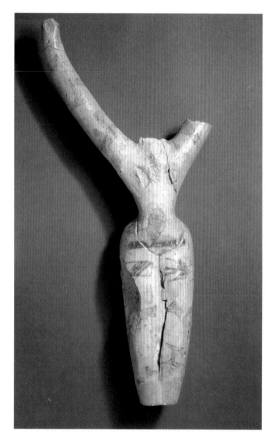

This Egyptian clay statue is over five thousand years old. The female figure is covered with decorations that are believed to represent tattoos.

was even older than that. Archaeologists have uncovered indications that Egyptians were tattooing with needles at least 4,500 years ago. That's around the same time the pyramids at Giza were built.

Inscriptions in the tomb of one tattooed Egyptian mummy identify her as Amunet, a priestess of Hathor. Hathor was the Egyptian goddess of love and protector of women. Amunet had abstract patterns of dots and lines on her arms, legs, and stomach. Other tattooed female mummies from about the same time have also been found. Like Amunet, these mummies had abstract tattoos—dots, lines, and diamond shapes.

So far, no tattooed male mummies have been found. Tattooing may have been reserved only for women in ancient Egypt. Since Amunet was a priestess, the tattoos may have had religious significance. It's also been suggested they were believed to be magic—endowed with the power to protect and promote fertility.

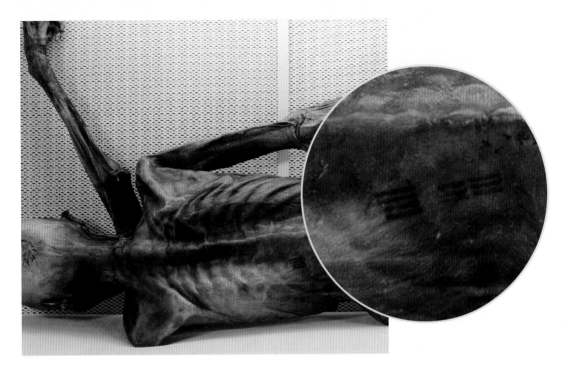

The oldest known tattoos are on this 5,300-year-old frozen mummy called "the Iceman." Over fifty simple tattoos appear on the body. In spite of the withered and darkened condition of the skin, the tattoos are still clearly visible. The inset shows tattoos on the mummy's back.

Polynesian Tattooing

Tattooing has been practiced in Polynesia for at least 3,200 years. Polynesia is the name given to a group of islands in the central and southern Pacific Ocean. It includes Tahiti, Samoa, Tonga, Easter Island, the Cook Islands, the Hawaiian Islands, New Zealand, and numerous other islands.

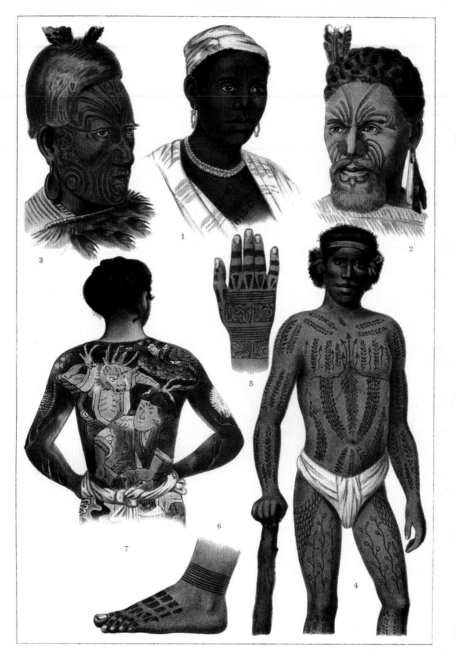

This nineteenth-century engraving illustrates several traditional tattooing styles from around the world, including facial and full-body tattoos. Figure 1: Africa. Figures 2 and 3: Polynesia (New Zealand). Figure 4: Polynesia (Caroline Island). Figures 5 and 6: Borneo. Figure 7: Japan.

Polynesian tattoos consisted of simple shapes such as lines, squares, circles, arches, and spirals, all done in black. The pigment was made by mixing water with the soot—the fine black powder in smoke—obtained by burning a type of oily nut. The tattooist applied the pigment with a tool made of a piece of bone or shell bound to a handle. The bone or shell had sharp teeth along one edge. The tattooist dipped the teeth into the pigment, placed the tool against the person's skin, and tapped it with a wooden paddle. According to eighteenth-century accounts, the process was extremely painful.

Different groups of Polynesians tattooed different parts of the body. For example, the people of Atiu, one of the Cook Islands, tattooed their stomachs and legs. *Pe'a*, the Samoan tattoo tradition, involved tattooing the lower body. The process was so dangerous that the person sometimes died. Tahitians favored tattoos that covered their buttocks, or bottom. The Maori of New Zealand gave most of their attention to facial tattoos, although other parts of the body might also be tattooed. Men were more extensively tattooed than women. Their facial tattoos, called *moko,* described the man's personal and family history. Different areas of the face gave different kinds of information:

- The center forehead area: rank
- The area around the eyebrows: status
- The area around the eyes and nose: tribal rank
- The temples: marriages
- The cheek area: work/profession/trade

- The area under the nose: the wearer's distinctive signature
- The chin area: prominence or reputation
- The jaw: birth status

Polynesian tattoos may have served other purposes as well. They might have been used to frighten the enemy in battle or mark rites of passage.

Tattooing in Asia

Japanese tattooing has a long history. For centuries, the Ainu women of the island of Hokkaido tattooed the backs of their hands and the area around their mouths. The Ainu were the original inhabitants of Japan and arrived there more than twelve thousand years ago. Among them, tattooing was an exclusively female practice.

Over time, the fashion changed, and men began to wear tattoos. Jimmu Tenno, the legendary first Japanese emperor, provides an early example. Accounts of his reign in the seventh century BCE describe his lavish tattoos. *Irezumi*, the traditional Japanese style of tattooing, had appeared by the third century BCE. *Irezumi* means "putting in ink." These tattoos were usually hidden under clothing.

Later emperors didn't follow Jimmu's model, and tattooing was instead used to punish and mark criminals by the fifth century CE. The status of tattoos changed again in the

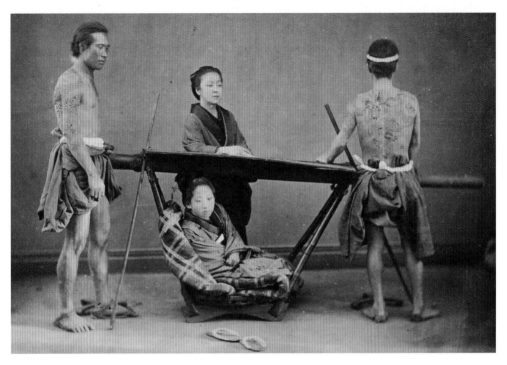

This photograph from around 1865 shows two Japanese men preparing to lift a *kago*, or sedan chair. Both men are heavily tattooed on their backs and upper arms. The touches of blue were added by hand. The artist's interest in the tattoos is revealed by the care he took in coloring them.

eighteenth century. It was then that a Chinese novel of the fourteenth century suddenly became popular in Japan. The full-body tattoos worn by many of the novel's Chinese heroes inspired a Japanese tattooing craze. When the government decided colorful kimonos, or robes, were an excessive luxury and banned them, it added fuel to the craze. Many men replaced their outlawed kimonos with elaborate tattoos that covered their back, the sides of their chest, and their upper arms and legs.

In 1872, the emperor banned tattooing for fear it would make a bad impression on foreign visitors. Tattooing remained illegal in Japan until after World War II, when it became associated with Japanese gangsters—the notorious *yakuza*.

Tattooing was also an important cultural tradition in other parts of Asia. The Pazyryks of ancient Russia practiced tattooing at least 2,400 years ago. We know this because of a discovery made in 1948. An archaeologist found the mummified body of a Pazyryk chieftain in the Siberian permafrost. The chieftain was heavily tattooed with interlacing animal figures. Tattoos covered his chest, arms, and legs. Small circles were tattooed along his spine. In 1993, another archaeologist found a mummified 2,400-year-old Pazyryk woman. Her clothing and elaborately carved casket indicated that she was a person of high status. Interlacing animal figures similar to those of the chieftain decorated her arms.

It has been suggested that the purpose of Pazyryk animal tattoos was magic or totemism. Individuals may also have desired to absorb the qualities of the animals in the tattoos. The circles along the chieftain's spine may have been meant to relieve pain.

Tattooing in Native North America

Almost all Native Americans practiced tattooing to some extent. Elaborate tattooing and other forms of body art played an important role in ancient Mayan civilization, which flourished in Mexico, Guatemala, Belize, and Honduras between about

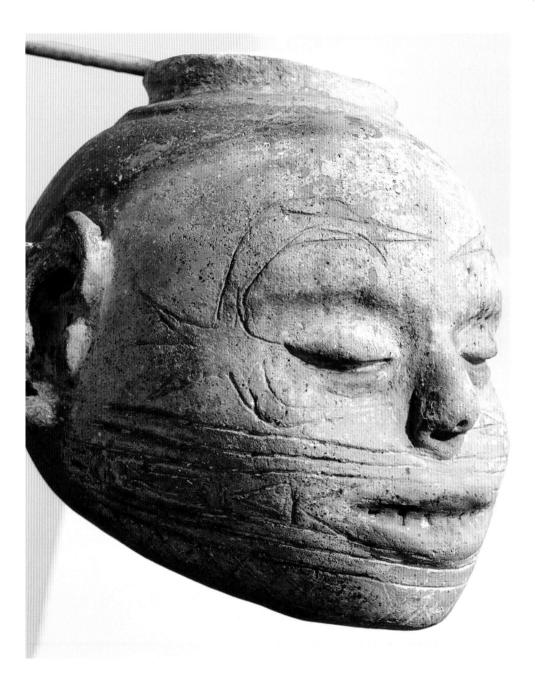

This Native American head pot was created around 1000 CE. The marks on the face are believed to represent tattoos and may be copies of the tattoos worn by the person with whom the pot was buried.

250 CE and 900 CE. The Maya tattooed themselves for both spiritual reasons and adornment.

Other Native Americans practiced tattooing for many reasons. A successful Osage warrior might have had a skull tattooed on his back or chest. An Omaha woman might have received tattoos to honor her father's brave deeds. Tattooing indicated high status among the Iroquois. Inuit men tattooed themselves to show how many whales they had killed. Inuit women's chin tattoos showed what group they belonged to and their marital status. Native Americans also used tattooing to indicate bravery or to mark slaves.

In spite of tattooing's importance in ancient cultures around the world, its acceptance by mainstream Western culture took a long time. Although it was practiced in ancient Greece and Rome, it was largely reserved for groups such as slaves and criminals. It never really became part of the mainstream. These negative associations limited tattooing's place in the Western culture that grew out of ancient Greek and Roman civilizations, as did the Catholic Church's condemnation of the practice. It wasn't until the eighteenth century that tattooing began to work its way into the mainstream.

How Tattooing Entered the Mainstream

The practice of tattooing declined in Europe during the Middle Ages, which began in the fourth century CE and lasted until about 1450. The Roman emperor Constantine the Great became a Christian around 312 CE and reportedly banned tattooing. The practice never completely disappeared, however, allegedly prompting Pope Adrian I to ban tattooing in 787 CE. In spite of the pope's ban, the practice persisted. Crusaders of the eleventh, twelfth, and thirteenth centuries got religious tattoos so whoever discovered their bodies would know to give them a Christian burial if they died abroad.

Throughout the Middle Ages, tattooing continued to be practiced in Europe. For example, Christian pilgrims who visited the Holy Land got tattoos to prove they had made the journey. However, tattooing no longer occupied the important and widespread cultural position it had among ancient societies. European encounters with other civilizations would create a new vogue for tattoos.

Captain Cook and Polynesia

British captain James Cook's voyage to the South Pacific reintroduced tattooing to Europe and aroused widespread interest in it among the upper classes. Cook's ship, the *Endeavour*, left England in 1768 and reached Tahiti in 1769. There, Cook and his crew encountered heavily tattooed Polynesians. The *Endeavour* then sailed to New Zealand, where the crew came in contact with the Maori and their moko tattooing tradition.

Joseph Banks, Cook's naturalist, kept extensive records of the cultures they came across. He wrote about tattooing and described the tattoos as well as the different traditions they found. Banks appreciated the artistic quality of Polynesian tattooing, the great skill of the tattooists, and the pain people endured in being tattooed. However, he doesn't seem to have understood the tattoos' meaning or the Polynesians' reasons for getting tattoos.

The ship's artist, Sydney Parkinson, made accurate drawings of tattooing implements and Maori moko tattoos. He also wrote detailed descriptions of the tools and the process. Parkinson and Banks both published their accounts of the voyage after the *Endeavour* returned to England. Cook also wrote and published a record of the voyage. These written accounts and the crew themselves introduced the word "tattoo" into the English language. Most people today believe the word is based on the Polynesian word *tatau*, which comes from the Polynesian word *ta*, meaning "to knock or strike." However, some people believe "tattoo" comes from the

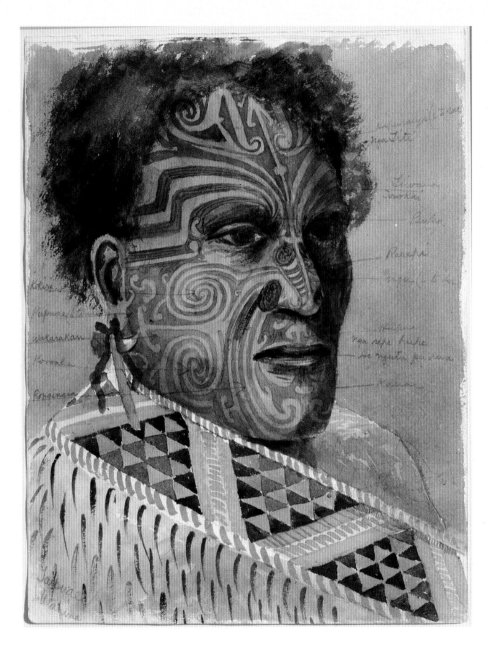

New Zealand artist Thomas Ryan created this watercolor portrait of a dignified Maori man around 1900. Notice how carefully Ryan painted the man's moko facial tattoos. Except for the border on the man's cloak, the rest of the portrait has very little detail. Ryan was clearly fascinated by the moko tattoos.

Traditional Sailors' Tattoos

Certain tattoos became traditional among sailors and served particular purposes or had specific meanings. According to Jean-Chris Miller in *The Body Art Book*, a rooster on one foot and a pig on the other were believed to protect a sailor from drowning. Swallows helped a sailor navigate the ocean and return home safely. They also measured the distance a sailor had journeyed. One swallow meant a sailor had traveled five thousand miles. Each additional swallow represented five hundred miles. Eileen Finan reports in "Is Art Just Skin Deep?" that a turtle meant a sailor had crossed the equator. An anchor meant he had sailed the Atlantic Ocean.

Javanese word *tau*, which means "a wound or scar." Regardless of the word's exact origin, it's something Cook's crew learned on their voyage and brought back to England with them.

According to R. W. B. Scutt and Christopher Gotch in "Early European Encounters with Polynesian Tattoos" (in J. D. Lloyd's *Body Piercing and Tattoos*), Parkinson got tattoos while the crew was in Polynesia. In *The Body Art Book*, Jean-Chris Miller reports that Banks received tattoos. Other members of Cook's crew from either the first voyage or a second voyage made in 1783 also received tattoos. These tattooed men attracted the attention of sailors in the British

navy, and within a few years, the tradition of the tattooed sailor had emerged. It soon spread to American sailors. Eileen Finan estimates in her *Time* magazine article "Is Art Just Skin Deep?" that 90 percent of all American sailors had tattoos by the nine-teenth century.

Cook, Banks, and other sailors, with their tattoos and tales of strange cultures, fascinated British royalty and the upper classes. They became popular guests at fashionable dinner parties. Soon aristocrats and members of the royal family were getting their own tattoos. King Edward VII received his first tattoo in 1862 and later acquired more. King George V had a dragon tattooed on his arm in 1882. Lady Randolph

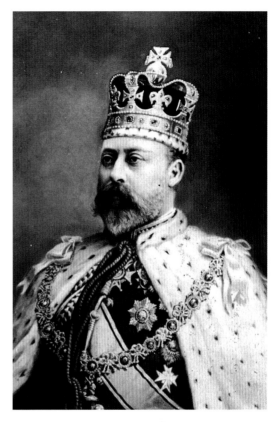

Edward VII appears here in full royal garb and crown. The photograph was taken in 1901, the year Edward became king. That was almost forty years after he acquired his first tattoo.

Churchill, the mother of future prime minister Winston Churchill, had a snake tattooed around her wrist. King Alfonso of Spain, King Frederick IX of Denmark, and Emperor Wilhelm II of Germany also got tattoos. After centuries of existing on the margins of European society, tattooing had emerged from the shadows.

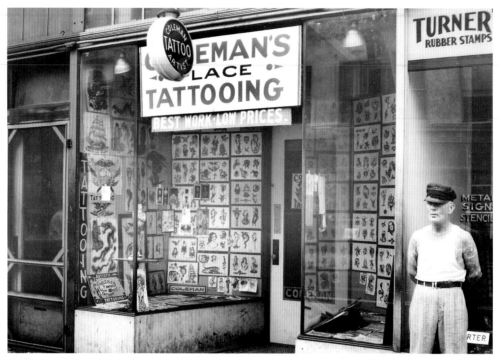

This 1936 photograph shows a tattoo parlor in Norfolk, Virginia, an important seaport. Mr. Coleman, the tattooist, stands next to his parlor. He's wearing a sleeveless undershirt to show off some of the tattoos he sports.

Tattooing's Shifting Status

Two developments around 1900 forever changed the practice of tattooing and the market for tattoos. Samuel O'Reilly had opened a tattoo parlor in New York City's Bowery around 1875. In 1891, he invented and patented the electric tattoo machine, which made tattooing faster and much less painful. O'Reilly's business flourished. As the number of tattoo customers grew, the number of tattoo parlors increased. By 1900, every major American city had tattoo parlors.

Whatever tattooing skills they possessed, many of the new tattooists lacked the ability to draw original designs. Tattooist Lew Alberts rescued these struggling artists. Alberts created thousands of designs that he sold through tattoo supply companies. These were the early version of what is today known as flash. Tattooists could buy these and trace them onto their customers' skin. Like O'Reilly's machine, Alberts's designs sped up the tattoo process.

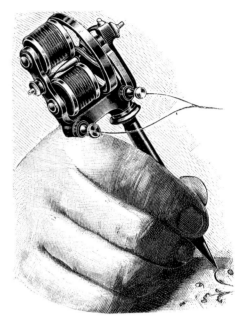

This illustration shows the electric tattoo machine invented by Samuel O'Reilly in 1891. The tattooist could hold it in his or her hand much like you would hold a pen or pencil.

As tattooing became easier and faster, it also became less expensive, thereby attracting more customers. Those factors, combined with the reduction in pain, allowed the tattooing market to greatly expand. Working-class people in the United States and England began to get tattoos. Royalty and the upper classes became less interested in tattoos once they became more accessible and less unique, however, and tattooing lost popularity with those groups.

As the market shifted, tattooing increasingly acquired negative associations. Tattoo parlors were often in decaying parts of cities where "respectable" people didn't go. They were often not sanitary, and customers risked infection and

disease from dirty needles and ink. People whose lifestyles were outside the mainstream, such as criminals and bikers, made up a growing portion of tattooists' customers, as did people who got complex, all-body tattoos in order to become featured attractions in circuses and carnivals.

The negative associations of tattooing began once again to shift in the 1960s, when tattooing found a new audience. The 1960s were a period of great social change. Young people from middle-class and upper-class homes rebelled against the prevailing social order, which they called the "establishment." They formed the counterculture, a new social movement that rejected what they viewed as the old-fashioned and stifling values of the mainstream culture of their parents. They began to get tattooed as part of their rebellion. Singers popular with "the youth generation" also got tattooed, which further encouraged tattooing among young people.

As a result, tattooing experienced a renaissance in the 1970s and gained new status. *Time* magazine published an article on the growing popularity of tattoos in 1970. Ink slingers and tattoo fans began to get together at tattoo events. In 1972, one of these events was the first international tattoo convention. New York City's Museum of American Folk Art held an exhibit of tattoo designs in 1971. Tattooing also became more professionalized. Health regulations made tattoo parlors cleaner and tattooing safer. People with college degrees in fine art became tattooists, and custom designs became more common. Tattooing's audience expanded as educated professionals began to get tattoos. In 1976, the National Tattoo Association

was founded. The association held its first national convention in 1979. Tattooing was no longer solely the realm of outsiders.

Tattooing Moves into the Mainstream

Events of the 1980s and 1990s confirmed tattooing's new status in Western society. In 1986, the National Museum of American Art—which is one of the museums that make up the Smithsonian Institution in Washington, D.C.—added tattoo design work to its permanent collection. Tattooing was no longer simply folk art; it was now fine art, equal to the work of other great American artists exhibited in the National Museum, such as Thomas Eakins, Georgia O'Keefe, and Jacob Lawrence. And if it was good enough for the National Museum of American Art, it was certainly good enough for other museums and galleries. Two New York City galleries exhibited tattoo art in 1995. Scholars held a conference on tattooing in Detroit, Michigan, in 1997. An exhibit of work by female tattoo artists occurred in a Buffalo, New York, gallery that same year. In 1998, several more New York City galleries exhibited tattoo art, and the University of Colorado–Boulder museum held an exhibit titled "Tattoo."

The language associated with tattooing reflected its new status as high art approved by great museums. The businesses formerly called "tattoo parlors" became known as "tattoo art studios." With all these developments came a new audience. Tattooing became popular with the educated middle class—a sure sign it had become acceptable to the mainstream of society.

Who Gets Tattoos and Why?

All kinds of people get tattoos today. Sailors and people who are, or want to be perceived as, "outsiders" decorate their bodies with skin art. Celebrities of all sorts have tattoos, often on highly visible parts of their bodies. Many "ordinary" people also have tattoos. This group can include your friends, neighbors, and family members. Not all people's tattoos are visible. Some people choose to get tattooed on parts of their bodies that will be covered by clothing. Often this is because visible tattoos are not acceptable in their job or within their families, peer groups, or communities.

What prompts people to get tattooed? Their motives are numerous and varied. Some get tattoos for the same reasons ancient people did. Others get tattoos for reasons that have more to do with the nature of modern society. Getting tattooed may help fulfill a need they feel society doesn't meet. Or it may be a way to rebel. The diverse motives confirm both the ancient and eternal power of skin art and its contemporary significance.

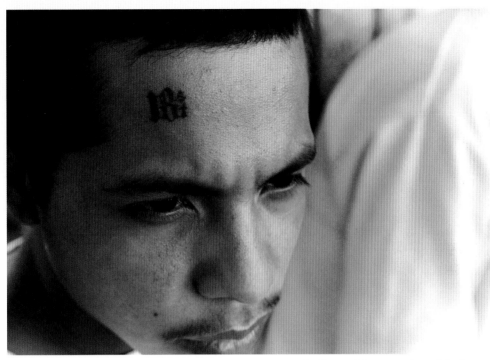

This young man from El Salvador has a tattoo to indicate his membership in the 18th Street Gang. The gang began in Los Angeles in the 1960s and is today one of the city's largest. Many young people who came to the United States to escape El Salvador's civil war joined the 18th Street Gang.

Who Gets Tattoos?

Sailors, who reintroduced tattoos to Western culture in the late eighteenth century, are still getting tattooed today. So are members of other branches of the military, who adopted the practice from sailors. Today's military men and women often still choose traditional naval tattoos, such as ships, anchors, hula girls, and mermaids.

"Outsiders"—those existing on the margins of society— were closely associated with tattooing in the early twentieth

century and continue to wear tattoos. This category includes convicts and gang members. Getting tattoos while in prison is prohibited, but convicts still find ways to tattoo themselves and others. Gang members, who used to get their first tattoo in their late teens, may start "sporting ink" today when they are only ten years old. Many people think of bikers, who may be heavily tattooed, as outsiders. However, all tattooed bikers don't fit that category. Some are simply weekend riders who work at conventional jobs during the week, not members of motorcycle gangs.

Outsiders occupy one end of the social spectrum of tattoo customers. At the opposite end are celebrities. The tattooed celebrity trend began around 1970. Blues and rock singer Janis Joplin was one of the first celebrities to get tattoos. Others soon followed, including members of the Rolling Stones, singer Joan Baez, and singer and actor Cher. An enormous number of contemporary celebrities have tattoos. Among the actors are Orlando Bloom, Johnny Depp, Jake Gyllenhaal, Scarlett Johansson, Angelina Jolie, and Brad Pitt. Singers include Christina Aguilera, Lance Bass, Beyoncé, Mary J. Blige, Tracy Bonham, Bow Wow, and 50 Cent. Among the famous athletes are David Beckham (soccer), Anna Kournikova (tennis), Eric Lindros (hockey), Willis McGahee (football), Mike Metzger (freestyle motocross), and Dennis Rodman (basketball). Famous fashion models include Naomi Campbell, Iman, and Kate Moss.

Of course, outsiders and celebrities make up only a small portion of people sporting ink. Most individuals with tattoos

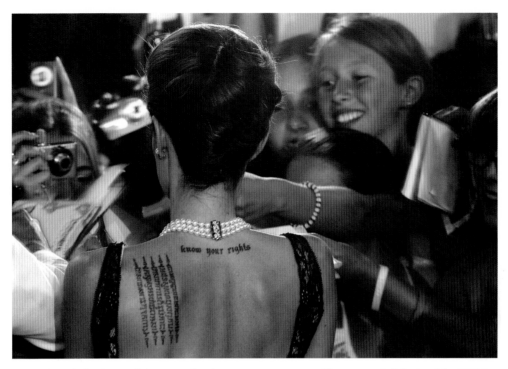

Angelina Jolie is well known for her many tattoos. Two are visible in this 2007 photograph of the actress being greeted by fans. The tattoo below her neck reads "know your rights." The tattoo on her left shoulder blade is a Buddhist prayer for her son Maddox, who she adopted in Cambodia.

are "regular" people. They're students, waiters, bank tellers, doctors, lawyers, "soccer moms," and business executives. They may be teenagers or great-grandmothers. According to Currie-McGhee in *Tattoos and Body Piercing*, about 10 percent of twelve- to eighteen-year-olds have tattoos. Almost as many people over sixty-five have tattoos. It's interesting to note that more and more women sport tattoos. According to Kenneth Korn in "Body Adornment and Tattooing: Clinical Issues and State Regulations," the number of women getting

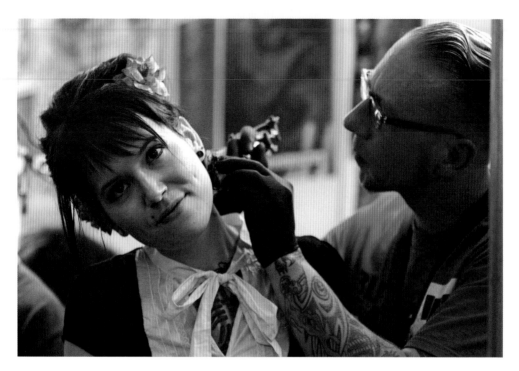

A tattoo artist at a 2007 convention in East London is tattooing the neck of a young woman. As is standard practice among tattoo artists today, the tattooist is wearing gloves similar to those worn by doctors and nurses in hospitals. This is just one of many methods modern ink slingers use to prevent the spread of infectious diseases.

tattoos was four times as great in 1996 as in 1976. Upper-middle-class white suburban women make up the fastest growing portion of the tattoo market. About equal numbers of men and women now wear tattoos. Altogether, more than forty-five million Americans are tattooed. That naturally leads to the question: What makes all these people get tattoos?

Modern Tattoos, Ancient Motives

People today often get tattooed for the same reasons people did thousands of years ago. Some assign magical powers to tattoos. Some people express spiritual devotion with tattoos of religious images or symbols, prayers, or quotes from holy books such as the Bible. In some cultures, tattooing indicated membership in a group or clan. People today also get tattoos to show group membership. Some people get tattooed for adornment. They may feel the tattoo itself adds beauty. Or they may use tattoos to cover scars, emphasize attractive body parts, or disguise imperfect ones. People may choose cosmetic tattooing,

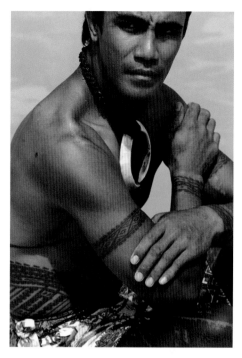

This young Samoan man shows off his pe'a tattoos. As is traditional, tattoos cover his body below his waist and on his upper legs. He also has bands tattooed around his upper arms and wrists.

also known as permanent makeup or micropigmentation.

In ancient times and in other cultures, rites of passage marked life events such as becoming an adult. Tattooing was often part of the ceremony, and the ability to withstand the pain was important to the ritual. Enduring the pain could be proof of courage or an indication that the individual was ready for the responsibilities of adulthood. People today often get tattoos to mark special life events, and the pain may be as

important as it was in the past. The event being honored may be reaching adulthood, graduation, marriage, the birth of a child, the death of a loved one, divorce, or surviving a serious accident or illness.

All these reasons for wearing ink link modern tattooing to the practice's long history. Contemporary people also get tattooed for reasons ancient people might not understand. These reasons have to do with characteristics of modern life that make it utterly different from life in ancient times.

Contemporary Reasons for Sporting Ink

Some people today get tattooed to fulfill needs modern society doesn't meet. For example, many people whose tattoos memorialize rites of passage feel modern society lacks community rituals that mark life transitions. For these people, the tattooing process becomes the ritual. Many tattoo artists meet this need for ritual with ceremonies that may include burning candles, placing offerings on an altar, and inviting loved ones to witness the tattooing.

Other people feel modern society is conformist and impersonal. Getting tattooed is a way to confirm their individuality. The tattoo is something permanent that society can't take away from them. Getting inked can be a way to take control of their bodies and their lives in a world in which they feel they have little control and other forces try to control them.

High school and college students often get tattoos to rebel. Since tattoos are more socially accepted than they once

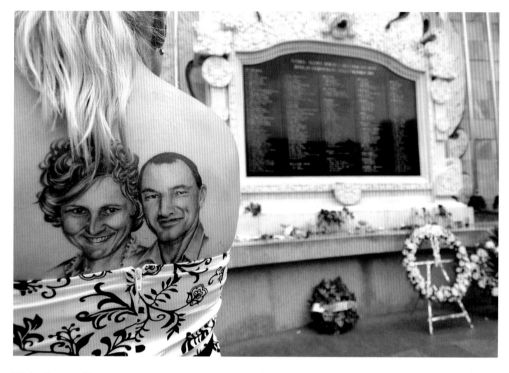

This Australian woman wears a memorial tattoo with portraits of her sister and brother. The two were on vacation when they died in bombings that occurred in Bali, Indonesia, in 2002. Following standard practice for portrait tattoos, the image is done in a fine-line, black-and-gray style that allows the tattoo artist to include a lot of details.

were, their message of revolt isn't as powerful or dramatic as it used to be. Yet because many parents and social and religious groups still oppose tattoos, they remain an effective form of rebellion for many young people.

Some people get tattoos to honor people important to them. The tattoos may be images, names or initials, or some combination of all of these. Memorial tattoos may honor loved ones or someone the wearer admires.

Other people get tattooed to celebrate their physical body. The tattoo permanently alters and perhaps increases appreciation of their bodies. The pain of the tattoo process makes people newly aware of their bodies and gives many a heightened sense of their physical selves.

Some people's tattoos are an extension of their interest in other cultures. They get tattoos that reference or honor the traditions of those cultures. These people are often called "modern primitives." Sometimes, they combine their interest in other cultures with futuristic ideas and blend their tattoos with piercings and implants inspired by modern technology.

A few people get tattooed to transform their bodies. For example, Tom Leppard, also known as Leopard Man, has had 99.9 percent of his body tattooed with a leopard-skin design. People seeking to transform their bodies often combine tattooing with other body modifications. Dennis Smith is tattooed all over with orange and black stripes. He also had his teeth filed to points and whiskers attached to his face. He's trying to become the tiger he believes he was meant to be. He has even legally changed his name to Cat Man.

Tattoo Styles and Designs

The decision to get a tattoo is much more complicated than it once was. Once upon a time, a tattoo was just a tattoo. You went to a tattoo parlor, chose a subject, and got tattooed. Today, individuals must consider which tattoo artist they want, what subject they want, what message they wish to convey with the tattoo, where they want the tattoo placed, and even what style they want. There are many styles and types to choose from. There are time-honored styles and types, some of which have been practiced for centuries. There are also contemporary styles that have emerged only recently. People select from among the many choices available.

People also choose the subject of their tattoo. The subject can be chosen from the studio's flash. Flash is the name for the designs displayed on the tattoo studio's walls. The subject can be a traditional subject that has a more or less established meaning. The subject can also be highly personalized, something with specific meaning for the wearer but whose significance is not always clear to others. The

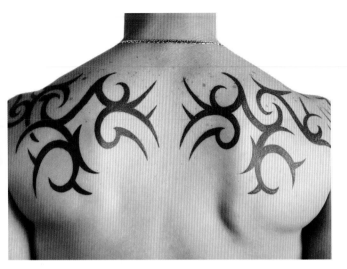

The tattoos across this young man's back provide a good example of tribal tattoos. Symmetry is an important feature of this tattoo, as it is of tribal tattoos in general.

possibilities are almost endless. With so much choice, it's not surprising that some people take a year or more to decide on a tattoo.

Time-Honored Styles

Time-honored tattoo styles are those that have been around at least half a century. Some have much older histories, including tribal tattoos. "Tribal" is a vague term. Kathlyn Gay and Christine Whittington define it in *Body Marks* as referring to styles and designs from native cultures around the world. However, "tribal" means Polynesian tattoos to most people. Tribal tattoos are generally black, abstract patterns with geometric or organic forms.

Traditional or "old school" tattoos are based on late nineteenth-century and early twentieth-century skin art. They're often associated with sailors and include traditional navy subjects: ships, anchors, daggers, hearts, hula girls, mermaids, and eagles. Traditional tattoos have simple designs, thick black outlines, solid areas of color, and little detail.

Cartoon and comic book characters such as Popeye have been popular skin-art subjects since the early twentieth century.

Today, more recent comic book and video game characters like Spider-Man and Mario enjoy popularity along with unicorns, wizards, and characters from cartoons and popular children's books such as *Winnie-the-Pooh*. According to Gay and Whittington in *Body Marks*, fantasy illustrations by Frank Frazetta and H. R. Giger (who created the alien in the movie *Alien*) are also popular image sources. Artists often use color to heighten the sense of fantasy.

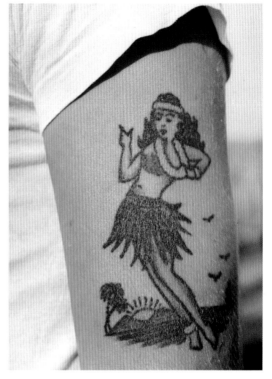

The U.S. sailor in this 1940 photograph sports a fine example of an "old school" tattoo on his upper arm: a hula girl swaying in front of a setting sun.

Black and gray ink is also known as "jailhouse" or "joint" style because it's based on prison tattoos. Since tattooing is prohibited in prison, inmates do it secretly with available materials. Ink comes from pens, the prison print shop, newspapers soaked in water, and cigarette ashes. This means the colors are mostly black and gray. Black and gray tattoos have fine lines, shading, and lots of detail.

Memorial or devotional tattoos honor a loved one or hero of the wearer. They commonly combine an image with words or initials. A familiar example is a heart with the words "I Love Mom." Memorial tattoos often honor someone who has died.

The tattoo might show the dead person's portrait along with his or her initials, or it might show a cross with a banner bearing the dead person's name. However, the person honored doesn't have to be dead.

Oriental tattooing usually refers to tattooing in the traditional Japanese style. Designs cover the entire body and may take years to complete. Many illustrate traditional stories and legends and are based on works by a famous nineteenth-century Japanese artist named Utagawa Kuniyoshi. Common elements are water, fish, dragons, and flowers. Oriental tattoos are colorful, with fine lines and lots of detail. The traditional method involves doing them by hand in a technique called *tebori*, which means "hand-carving."

Cosmetic tattooing, or micropigmentation, might seem like a new type of tattooing. However, it has actually been done since the early twentieth century. It commonly involves tattooing eyeliner, eyebrows, and lip and cheek color.

The time-honored styles offer many possibilities to people who want to get inked. However, they're not the only choices. In recent years, several new styles have increased the variety of styles available.

Contemporary Styles

As the market for tattoos has grown, the variety of styles available has also increased. Many of today's styles didn't even exist just a few years ago.

"New school" tattoos take time-honored styles such as old school and Oriental, and combine them with fine-art and folk-art traditions. Their subjects are no longer limited to the traditional subject matter of time-honored styles. Their range of colors is greatly expanded over that of older styles. Bright, bold colors are favored. "Wild style" is also one of the newest styles. It's based on urban culture. It takes elements from hip-hop and from skateboard and graffiti art.

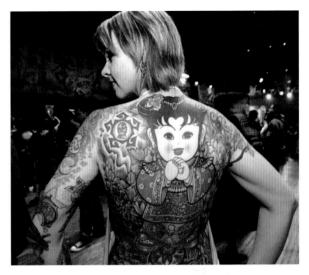

A woman displays the elaborate tattoos covering her entire back during the annual New York City Tattoo Convention.

Celtic tattoos are based on the fine and decorative art of seventh- and eighth-century medieval Ireland. The art was characterized by complex interlacing patterns called knotwork. It also included figures of people and animals that were abstract and decorative rather than realistic. Some Celtic tattoos are colorful, while others have very little color.

"Darkside" tattoos deal with death, evil, and fear. The subjects have a long history in skin art. What makes darkside tattoos new is their style, inspired by fantasy, science-fiction, and horror illustrations. Darkside tattoos have fine detail and smooth shading.

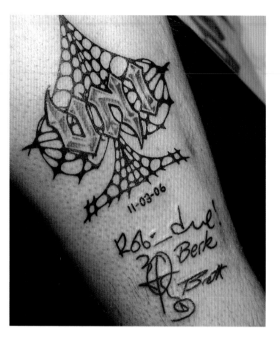

Mötley Crüe singer Vince Neil got this tattoo at the opening of his tattoo studio, Vince Neil Ink, in Las Vegas, Nevada. A spade—a symbol for one of the suits in a deck of cards—forms a fitting background for the studio's initials, VNI. The names below it are done in different styles to duplicate individual signatures.

Biomechanical tattoos draw inspiration from the part human/part machine images of H. R. Giger of *Alien* fame and Clive Barker, whose accomplishments include the movie *Hellraiser*. They are often *trompe l'oeil* images—that is, they are meant to "fool the eye" into believing it's looking at reality rather than an image. In *The Body Art Book*, Miller presents the example of a tattoo that gives the illusion the wearer's skin has been peeled back to reveal metal rods and computer boards rather than flesh and bone.

Typographic tattoos may be a surprise if you think of tattoos primarily as images. Typographic tattoos are composed of words. Some are just a word or two. Others are a phrase. Still others are long quotes from a poem or book. Some are so long they cover the wearer's entire arm or leg. A few show just a symbol such as the sign for "and" (&) or a punctuation mark such as a semicolon (;). Most typographic tattoos are black, although some include color. You might expect the lettering in all typographic tattoos to look the same, but that's not true. There are many different typefaces, or styles of lettering. People choose their lettering style very carefully.

The Art of Mehndi

Temporary tattoos provide an alternative to permanent skin art. *Mehndi*, the art of creating temporary henna tattoos, has been practiced for at least four thousand years in South Asia, the Middle East, and North Africa. The leaves of the henna bush are dried, ground to a powder, then mixed with oil and a liquid such as water or tea to form a thick paste. The paste is used to paint intricate designs on the skin. A coating of lemon juice and sugar is applied to keep the paste stuck to the skin. After two to twelve hours, the dry paste is scraped off. It leaves a light orange to deep brownish black tattoo, which lasts one to three weeks.

An individual getting tattooed must select not only the style but also the design or subject. Choices were limited a century ago. However, in today's world, the number of possibilities is vast.

Designs and Symbols

A person can select the design for his or her tattoo from the studio's flash. Some designs show traditional images such as anchors or hearts. Others may be designs that the studio artists created and will tattoo on anyone for a set fee. Still others may be designs purchased from tattoo supply companies.

An individual can also choose to be tattooed with a custom design. A custom design is one created at a customer's request by a tattoo artist or by the artist working with the customer. It's a one-of-a-kind work.

Flash and some custom designs may include common tattoo symbols. Many of these symbols have more or less fixed meanings. Below is a list of some common symbols and their meanings.

- **Anchor:** The wearer has sailed the Atlantic Ocean; a talisman to prevent the ship from sinking; salvation (for Christians)
- **Angel:** Protector; divine messenger
- **Bear:** Wisdom; unconquerable
- **Bird:** Spirituality
- **Boat:** Spiritual journey
- **Butterfly:** Soul's ability to fly from the body; rebirth; transformation
- **Cat:** Associated with women and witchcraft
- **Devil:** Worldly concerns; earthly desire
- **Dog:** Loyalty; devotion
- **Dolphin:** Salvation
- **Dragon:** Ultimate enemy; fear that a person must overcome; guardian
- **Eagle:** Power; war
- **Fairy:** Unseen, supernatural forces
- **Fire:** Death; destruction; spiritual rebirth

- **Frog:** Fertility; birth
- **Heart:** Love; eternal soul
- **Lion:** Brute strength
- **Skeleton:** Death
- **Snake:** Immortality; strength; evil; healing through transformation
- **Spider:** Creativity; infinity; chaos
- **Sun:** Power; heroism; courage; source of all life
- **Tiger:** Wrath; cruelty
- **Unicorn:** Purity; innocence
- **Wolf:** Dark, destructive side of humans

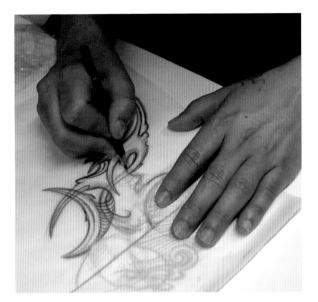

This tattoo artist is making a paper stencil of a finished tattoo design. The artist will moisten the customer's skin, then press the stencil against it. When the paper is pulled away, the design remains on the customer's skin. The transferred design guides the tattooist as he or she works.

In the end, however, the tattoo a person chooses—whether it is flash or a custom design—is usually selected because it means something special and personal to the individual. So you can't rely on the standard meanings of symbols to understand someone else's ink. You have to get to know the wearer and learn what the tattoos mean to that person.

Some Famous Tattoo Artists

Over the last century, thousands of ink slingers have contributed to the growth and development of tattooing. Today, every state in the United States has tattoo art studios. More than three thousand registered tattoo artists belong to the Alliance of Professional Tattooists (APT). There are also underground ink slingers who work in unmarked, unadvertised shops, usually in places where tattoo parlor laws, licensing, and regulations are more restrictive. In addition, new tattooists enter the profession every year. Below, you can read about some of the best-known tattoo artists of the past and present. Of course, there are now too many famous tattoo artists for them all to be included here. There are also many fine tattooists who aren't famous. The artists discussed below are just a sampling of those who have helped shape the profession.

Sailor Jerry: Tattoo Visionary

Tattoo artist Shanghai Kate has said the history of tattooing can be divided into two periods—

before Sailor Jerry (BSJ) and after Sailor Jerry (ASJ). That's how important he was to the development of tattooing.

Sailor Jerry was born Norman Keith Collins. He was a real sailor who became an ink slinger and operated a tattoo parlor in Honolulu, Hawaii. In the 1940s, Sailor Jerry became known as the greatest American tattooist of the time. He devoted himself to raising both the quality and the status of tattooing.

When Sailor Jerry began tattooing, American tattooists used only three or four colors. Sailor Jerry searched for additional pigments tattooists could use safely. When he found a new one, he tested it on himself first to ensure its safety. His discoveries greatly expanded the range of colors available to tattooists. Sailor Jerry also found new power sources for tattoo machines and invented new machines and new ways to arrange the needles. His inventions made tattooing less painful.

Some of Sailor Jerry's most important contributions made tattooing safer as well. He was one of the first to use "single-service" products. These were products such as needles and inks that would be used for one customer only, then thrown away. He was also one of the first to use a machine called an autoclave to sterilize his equipment. These changes from earlier methods helped prevent the spread of infectious diseases.

Sailor Jerry helped to change the idea of what a tattoo was. The American tradition was separate, unrelated tattoos scattered on the body. Inspired by Japanese tattooing, Sailor Jerry promoted the notion of large, unified, custom designs.

Before Sailor Jerry, tattooists worked in isolation from each other. He changed that. He corresponded with tattoo

artists around the world and helped create an international network. Ink slingers began to compare ideas and methods and trade flash. A sense of community emerged. In 1972, Sailor Jerry organized the first international tattoo convention. Only seven artists were present, but it was a watershed event for the industry and its artistic development.

Without Sailor Jerry, tattooing might not be what it is today. However, Sailor Jerry was not the only tattooist who helped create modern tattooing. Many other artists played a role.

Other Founders of Modern Tattooing

Tattoo artist Phil Sparrow—whose real name was Samuel Stewart—spent twenty years as a university professor before he became a tattoo artist in 1954. Sparrow was interested in all styles, but he especially promoted Japanese tattooing.

Sparrow influenced many later tattooists. One was Don Ed Hardy. Hardy received his first tattoos from Sparrow in 1966 and was so impressed he became Sparrow's apprentice. After a short apprenticeship, he devoted himself to raising tattooing's status as an art. Through Sailor Jerry, he met Japanese tattoo artist Kazuo Oguri and went to Japan to study traditional tattooing methods. After returning to the United States, he popularized the Oriental style. In 1982, Hardy began publishing a magazine called *Tattootime*.

In addition to Hardy, Sparrow influenced Cliff Raven. Raven was a commercial artist with a college art degree. Meeting Sparrow in 1958 led Raven to become a tattoo artist. He's

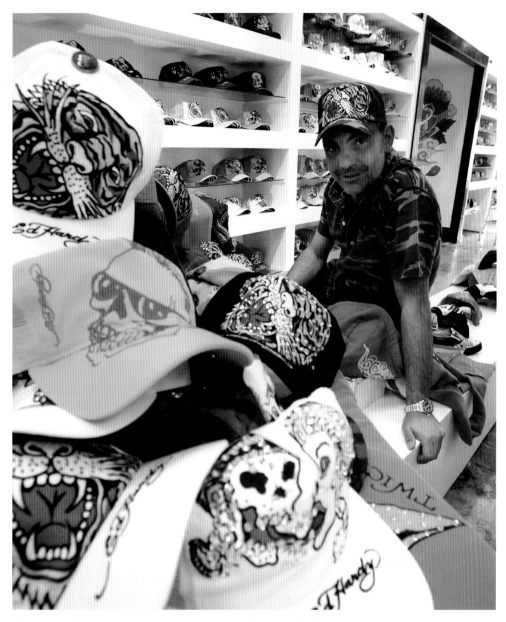

Christian Audigier, shown here in the Ed Hardy Store in Los Angeles, California, is a renowned fashion designer whose clothes are popular with many celebrities. He has created a clothing line based on the tattoo art of famed tattooist Don Ed Hardy. The clothing line is called Ed Hardy by Christian Audigier.

credited with pioneering tribal tattooing in the United States in the early 1960s. Like Sailor Jerry, he promoted sterilizing instruments with the autoclave and using single-service inks.

Lyle Tuttle began tattooing in 1952 in San Francisco, where his customers included many celebrities. Tuttle realized tattooing couldn't move into the mainstream until tattoo parlors lost their reputation as unsanitary places. He played a major role in getting government health regulations for tattoo shops passed in the 1970s. As a result, more middle-class people began to get inked.

Women such as Ruth Marten, Jill Jordan, Vyvyn Lazonga, and Shanghai Kate Hellenbrand emerged as important artists in the 1970s. Hellenbrand is sometimes called the Godmother of the Tattoo World. She began tattooing in 1971, the year she helped organize the tattoo exhibit at New York City's Museum of American Folk Art. She studied with Sailor Jerry and Don Ed Hardy, and was one of the seven artists at the first international tattoo convention organized by Sailor Jerry in 1972. Her award-winning work has appeared in all major tattoo magazines. She writes for the magazines *Tattoo Planet, Skin & Ink*, and *International Tattoo Art*. She has also appeared on the *Today Show* and in programs on the Travel Channel and the Discovery Channel.

Leo Zulueta learned tattooing from Don Ed Hardy in 1981. Credited with popularizing tribal tattoos in the 1980s, he's known as the Father of Tribal Tattooing. Zulueta's tattoos were inspired by Polynesian tattoos but didn't directly copy them. He felt only Polynesians had a right to wear true Polynesian tattoos.

While some of the founders of modern tattooing are now dead, others continue to practice their art and influence its development. Artists who have entered the field more recently are also shaping its future.

Some Famous Contemporary Tattooists

Many fine artists practice tattooing today. Here's a look at a few of these artists.

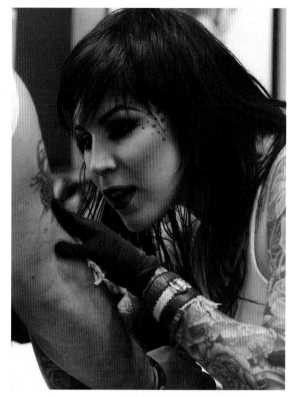

Kat Von D, of L. A. Ink, carefully and artfully inks a tattoo onto a customer's arm.

Pat Fish received degrees in art and film from the University of California–Santa Barbara, where she taught art for three years. Then, in 1984, she became a tattooist and opened a studio in Santa Barbara. Fish trained with Cliff Raven. She's famous for her Celtic tattoos and is known as the Celtic Queen of the West Coast. Customers come from all over the country to get tattooed by her. Fish herself wears ink by her teacher, Raven, as well as by Don Ed Hardy and Leo Zulueta. She also sports tattoos by contemporary artists Trevor Marshall and Alex Binnie.

Two Famous Early Tattooists

Martin Hildebrandt came to the United States from Germany and began tattooing in 1846. Like other tattooists of the time, he had no permanent shop but traveled around. During the American Civil War, he earned a good living tattooing soldiers and sailors from both the North and the South. Around 1870, he established the first American tattoo parlor in New York City.

George Burchett was a famous tattooist in London, England, in the late 1800s and early 1900s. Known as the King of Tattooists, his customers included King Alfonso of Spain and King Frederick IX of Denmark. He also did much cosmetic tattooing for upper-class English women.

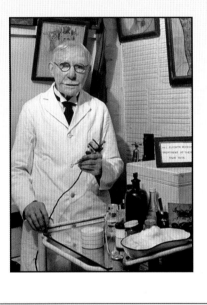

Looking much like a doctor in his office, King of Tattooists George Burchett poses in his tattoo studio in this 1951 photograph.

Trevor Marshall is one of many contemporary artists influenced by Zulueta. He has a studio in New Hampshire and also works as a guest artist at a studio in New Zealand.

New York City artist Paul Booth practices a black-and-gray Oriental style that resembles traditional Chinese art and has

long been admired by Chinese tattooists. In 2004, the China Association of Tattoo Artists brought Booth to Beijing to present a teaching seminar to the association's members.

Kat Von D (Katherine Von Drachenberg) is a talented tattoo artist who has achieved fame as a result of her role on the television reality tattoo series *Miami Ink* and *LA Ink*. In 2007, at the age of only twenty-five, she was the featured artist at Rick's 12th International Tattoo Convention in Green Bay, Wisconsin. Her celebrity status drew huge crowds to the convention, helping to raise awareness and appreciation of tattooing as an art.

Steve Gilbert of Toronto, Canada, is a tattoo artist and historian. He creates oriental tattoos using the traditional tebori method, which he learned from the great Japanese tattoo artist Kazuo Oguri. He has also written an important history of tattooing titled *Tattoo History: A Source Book*.

Alex Binnie is a celebrated artist with a studio in London, England. He works in the tribal style. Inia Taylor III is a Maori artist who creates traditional Maori and other Polynesian tattoos. Taylor worked as an art director for the movies *Once Were Warriors* and *What Becomes of the Broken Hearted?* in the early 1990s. For those movies, he had to draw temporary tattoos on actors. After the movies, he wanted to learn the traditional Maori tattoo methods but had trouble finding anyone who knew them. Under the influence of English settlers, the Maori had become ashamed of their culture and quit tattooing. Taylor finally found Paulo Suluape, a Samoan artist living and

working in New Zealand. Suluape trained him, and together they helped save Maori tattoo traditions from disappearing completely.

The tattoo artists discussed here, along with many other fine contemporary tattooists, lead the current trends in tattooing. Where will tattooing go from here? No one knows for sure. Ink slingers who haven't even begun tattooing yet will chart new courses for the art. Although we don't know where they will take it, we can count on new and exciting developments in this most ancient, enduring, and vital of art forms.

GLOSSARY

apprentice A person who learns a trade by working for someone who is already trained.

cave painting A painting made on cave walls by prehistoric people between ten thousand and thirty thousand years ago.

Celtic Having to do with the ancient Celts, who occupied, Ireland, England, Scotland, Wales, France, Spain, and western Asia, or with their language or culture.

Crusader A person who fought in the wars begun by European Christians, who tried to take back the Holy Land from the Muslims in the eleventh through the thirteenth centuries.

fine art Art forms such as painting and sculpture that are exhibited in museums and that people usually think of when they hear the word "art."

flash Tattoo designs displayed on studio walls for customers to choose from.

folk art Art created by often anonymous artists who lack formal training.

geometric Having to do with straight lines, circles, and other simple shapes.

graffiti Unauthorized writing or drawing on public surfaces such as bridges or the walls of buildings.

hip-hop The culture associated with inner-city young people who are fans of rap music.

implant An object inserted under the skin for the purpose of body modification.

ink slinger A tattoo artist.

mainstream The dominant tastes and opinions in a culture.

mummy A body treated for burial in a way that preserves it for an extremely long period of time. Also, a body that has been similarly preserved by natural elements.

organic Resembling a living, growing thing.

permafrost A permanently frozen layer of soil below the surface.

piercing A hole pierced in the body for the purpose of inserting jewelry.

pigment A coloring matter in animals and plants.

renaissance A rebirth or revival of something.

rite of passage A ritual associated with a change of status for an individual.

sanitary Characterized by cleanliness.

shading Markings made inside the outline of a form to suggest shadow and give the illusion of three-dimensionality.

spiral A curved line that is coiled most tightly around a center point and relaxes as it unwinds.

sterilize To get rid of germs.

talisman Something that seems to produce magical effects.

typographic Having to do with the style and appearance of letters.

For More Information

Alliance of Professional Tattooists, Inc.

9210 South Highway 17-92

Maitland, FL 32751

(407) 831-5549

Web site: http://www.safe-tattoos.com

The Alliance of Professional Tattooists, Inc., is a nonprofit organization that focuses on health and safety issues related to tattooing. It provides seminars for tattooists as well as informational materials for the public and lawmakers.

The American Academy of Micropigmentation

741 North Kalaheo Avenue

Kailua, HI 96734

(800) 441-2515

Web site: http://www.micropigmentation.org

The American Academy of Micropigmentation seeks to improve the quality of cosmetic tattooing by promoting excellence, encouraging continuous learning, and providing certification for tattooists who meet its standards.

Canadian Federation of Body Modification

2450 Weston Road, Box #2508

Toronto, ON, Canada M9N 2A3

Web site: http://canadianfbm.googlepages.com

The Canadian Federation of Body Modification is composed of body modification professionals and people who practice body modification. Its mission is to encourage the growth of the industry and protect the health and safety of professionals and customers through education and certification.

National Tattoo Association, Inc.
485 Business Park Lane
Allentown, PA 18109
Web site: http://www.nationaltattooassociation.com
The National Tattoo Association, Inc., works to increase public awareness of tattooing as an art form and to advance quality, safety standards, and professionalism in the field.

The Society of Permanent Cosmetic Professionals
69 North Broadway
Des Plaines, IL 60016
(847) 635-1330
Web site: http://www.spcp.org
The Society of Permanent Cosmetic Professionals promotes safety, excellence, and professional standards through education, certification, and industry guidelines. Permanent cosmetics, also called permanent makeup or micropigmentation, is cosmetic tattooing.

Web Sites

Due to the changing nature of Internet links, Rosen Publishing has developed an online list of Web sites related to the subject of this book. This site is updated regularly. Please use this link to access the list:

http://www.rosenlinks.com/ttt/tims

FOR FURTHER READING

Aveline, Erick, and Joyce Chargueraud. *Temporary Tattoos.* Buffalo, NY: Firefly Books, 2001.

Di Folco, Philippe. *Skin Art.* Paris, France: Fitway Publishing, 2004.

Erickson, Larry, ed. *Miami Ink: Marked for Greatness.* New York, NY: TLC, 2006.

Green, Terisa. *Ink: The Not-Just-Skin-Deep Guide to Getting a Tattoo.* New York, NY: New American Library, 2005.

Green, Terisa. *The Tattoo Encyclopedia: A Guide to Choosing Your Tattoo.* New York, NY: Simon & Schuster, 2003.

Perlingieri, Blake Andrew. *A Brief History of the Evolution of Body Adornment in Western Culture: Ancient Origins and Today.* Liverpool, England: Tribalife Publications, 2003.

BIBLIOGRAPHY

Baxter, Bob. "Kat Von Dee in Green Bay." *Skin & Ink*, 2007.
Retrieved November 11, 2007 (http://www.skinink.com/
archives/0807/feature.html).

Boeckel, Rik van. "Inia Taylor III—Keeping the Tradition Alive."
Skin & Ink, 2007. Retrieved November 11, 2007 (http://
www.skinink.com/archives/1207/feature.html).

Chesanow, David. "Fil-Am Pioneer of Tattoo Trend."
AsianWeek.com, 2002. Retrieved November 9, 2007
(http://asianweek.com/2002_06_28/arts_tribal.html).

Currie-McGhee, Leanne K. *Tattoos and Body Piercing*.
Farmington Hills, MI: Lucent Books, 2006.

Disha. "Tattoo Artist of the Week: Shanghai Kate." Tattooblog,
2007. Retrieved November 10, 2007 (http://www.tattooblog.
org/entry/tattoo-artists-of-the-week-shanghai-kate).

Finan, Eileen. "Is Art Just Skin Deep?" *Time*, 2002. Retrieved
November 10, 2007 (http://www.time.com/time/magazine/
article/0,9171,901020429-232673,00.html).

Gay, Kathlyn, and Christine Whittington. *Body Marks: Tattooing,
Piercing, and Scarification*. Brookfield, CT: Twenty-First
Century Books, 2002.

Hellenbrand, Kate. "Sailor Jerry." ShanghaiKates.com, 2002.
Retrieved November 10, 2007 (http://www.shanghaikates.
com/Sailor_Jerry/SailorJerry1.html).

Korn, Kenneth. "Body Adornment and Tattooing: Clinical Issues and State Regulations." *Physician Assistant*, Vol. 20, May 1, 1996, p. 85.

Lautman, Victoria. *The New Tattoo*. New York, NY: Abbeville Press, 1994.

Levins, Hoag. "The Changing Cultural Status of the Tattoo Arts in America." TattooArtist.com, 1997. Retrieved November 16, 2007 (http://www.tattooartist.com/history.html).

Lloyd, J. D., ed. *Body Piercing and Tattoos: Examining Pop Culture*. Farmington Hills, MI: Greenhaven Press, 2003.

McCabe, Mike. "Paul Booth in Beijing." *Skin & Ink*, 2005. Retrieved November 11, 2007 (http://www.skinink.com).

Mcgue, Kevin. "Horiyoshi III, Legendary Irezumi Master." *PingMag*, 2007. Retrieved November 19, 2007 (http://pingmag.jp/2007/10/11/irezumi-horiyoshi).

Miller, Jean-Chris. *The Body Art Book*. New York, NY: Berkley Books, 2004.

Oberosler, Danielle. "The Controversial Queen of Celt." *Skin & Ink*, 2003. Retrieved November 9, 2007 (http://www.skinink.com).

Oguri, Kazuo. "My Life in Tattooing." Tattoos.com, 1996. Retrieved November 19, 2007 (http://tattoos.com/oguri/oguribio.htm).

Saltz, Ina. *Body Type: Intimate Messages Etched in Flesh*. New York, NY: Abrams Image, 2006.

INDEX

About the Author

Janey Levy is an editor and writer who lives in Colden, New York. She has written more than seventy-five books for young readers. Levy has a Ph.D. in art history and is interested in all forms of visual art and the relationship between art and society. She has published articles and essays on paintings, prints, and maps.

Photo Credits

Cover (top) Getty Images; cover (bottom) Doug Pensinger/Getty Images; p. 5 William Thomas Cain/Getty Images; p. 10 © Ashmolean Museum, University of Oxford, UK/The Bridgeman Art Library; p. 11 South Tyrol Museum of Archaelogy, Bolzano, Italy/The Bridgeman Art Library/Getty Images; p. 12 The Print Collector, Great Britain/HIP/Art Resource, NY; p. 15 Hulton Archive/Getty Images; p. 17 © Werner Foreman/Topham/The Image Works; p. 21 © Private Collection/© Michael Graham-Stewart/The Bridgeman Art Library; p. 23 Mansell/Time & Life Pictures/Getty Images; p. 24 © The Mariners' Museum, Newport News, VA; p. 25 © Mary Evans Picture Library/The Image Works; p. 29 © Eros Hoagland/Zuma Press; p. 31 Chris Jackson/Getty Images; p. 32 Shaun Curry/AFP/Getty Images; p. 33 © Joe Carini/The Image Works; p. 35 Sonny Tumbelaka/AFP/Getty Images; pp. 38, 45 Shutterstock.com; p. 39 Carl Mydans/Time & Life Pictures/Getty Images; p. 41 Stan Honda/AFP/Getty Images; p. 42 Ethan Miller/Getty Images; p. 49 Vince Bucci/Getty Images; p. 51 Matthew Simmons/WireImage; p. 52 Brian Seed/Time & Life Pictures/Getty Images.

Designer: Les Kanturek; **Photo Researcher:** Cindy Reiman